D0066075

Voice of the Waters

A DAY IN THE LIFE OF A LOON

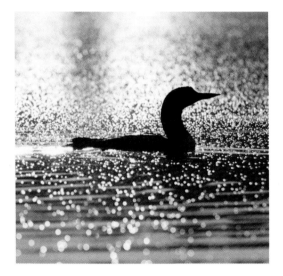

Tom Klein

PHOTOGRAPHY BY
Carl R. Sams II and Jean Stoick

NorthWord Press
Minnetonka, Minnesota

Many people clearly recall their first experience with loons, and people almost always remember the first time they heard loon music. I'm slightly embarrassed to admit I don't. While boyhood trips to northern Wisconsin produced a few loon encounters, nothing special happened. It wasn't until one August that loons grabbed my soul. With a high school buddy, I drove to the lake, to start a great adventure.

We brought everything on that trip, including a six-pound tackle box, an ax, two machetes, two sleeping bags worthy of an arctic expedition, and a steel ammo case to protect our eight pounds of bacon. After a long day's paddle and portage, we made it to a spot to camp. Shoulders bright red from the August sun and sore from the sharp bite of the thin pack straps, we settled into the campsite surrounded by a reassuring audio backdrop of falling water.

The loons on the lake called that night, probably no louder nor more often than they do on any other August night. But the calling found the right spot. We sat by the campfire bewitched, anticipating two weeks of granite cliffs, water diamonds on the shimmering lakes, firm lake trout, spongy sphagnum moss, and quiet evenings with the voices of the wilderness.

That night we didn't know the difference between the tremolo, wail, or yodel. And we didn't care. We just soaked it all in. It was a magical night.

I haven't kept track of my buddy over the passing years so I can't speak for him, but nothing has been the same for me since.

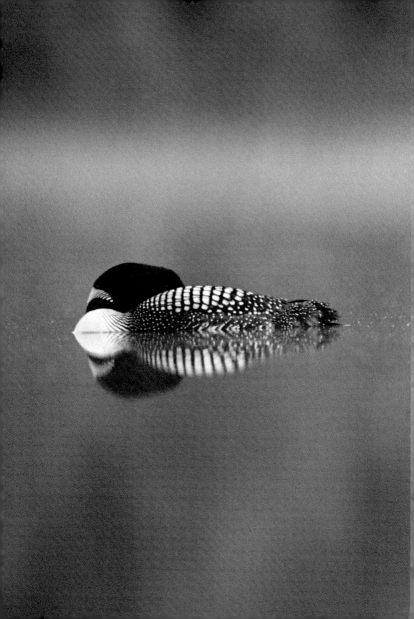

Slowly, the total blackness of a night with no moonlight begins to recede and the faintest hints of light are seen in the east.

After floating in the cove all night, a loon, still with its head tucked back under its wing, watches the lake become visible in the early morning light.

Greeting the new day, the loon raises its head and looks around. Only fifty feet away, its mate sits motionless on the nest, covering the eggs, insulating them from the early morning chill. The loon on the water hoots softly and his mate returns the gentle call.

Turning to face the open water of the lake,
the loon suddenly rears up with its neck
outstretched, bill pointing to the sky,
and flaps his wings vigorously.

Settling back on the water, he begins to swim slowly along the shoreline, occasionally peering beneath the water's surface.

As he swims, he stops to preen his feathers. Obtaining oil from a gland beneath his tail, he draws his wing feathers through his bill one at a time, reconnecting the web of hooks and shafts and covering the feathers with natural waterproofing. He preens meticulously making sure no feather is missed.

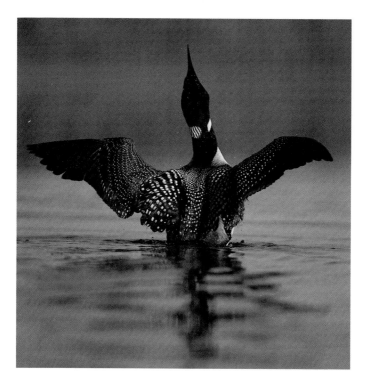

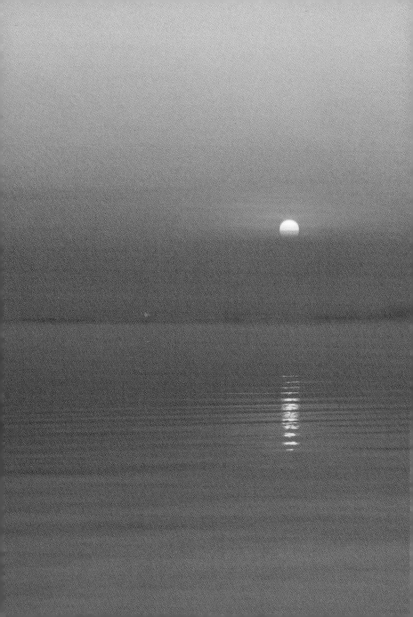

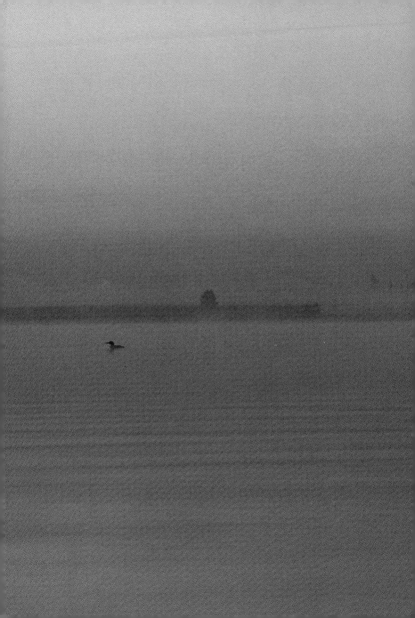

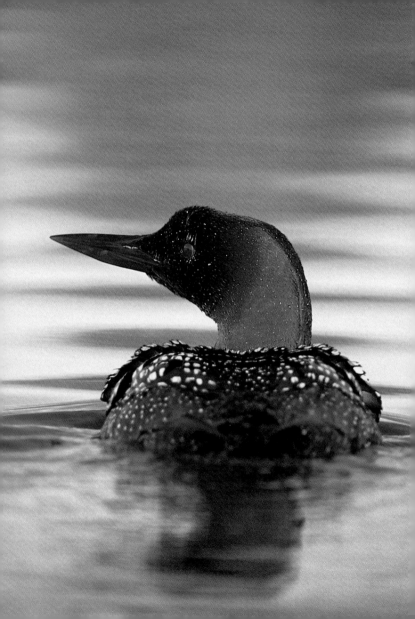

At one point, he stretches back and rubs his head against his back feathers to waterproof one of the few places on his body he can't reach with his bill.

A fish darting in the shallows catches his attention, but he doesn't chase it.

Instead, he continues to patrol the boundaries of the part of the lake he and his mate have claimed as their territory for the summer.

Stopping over a submerged reef, the loon peers intently into the depths.

Upon spotting a small fish, he dives quickly and pursues it, but it escapes into a weed bed. The loon resurfaces and shakes the water from his head. Several more forays along the reef fail to produce a fish.

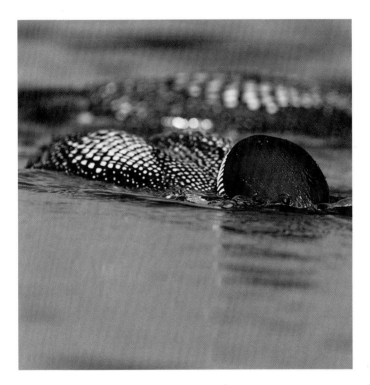

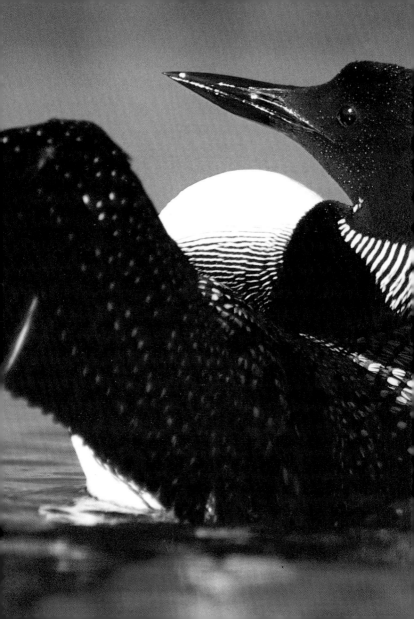

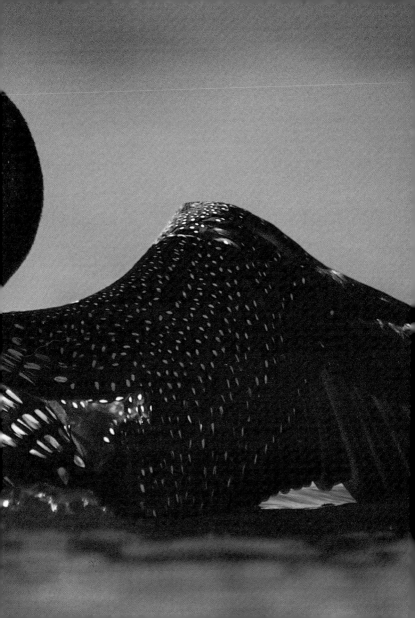

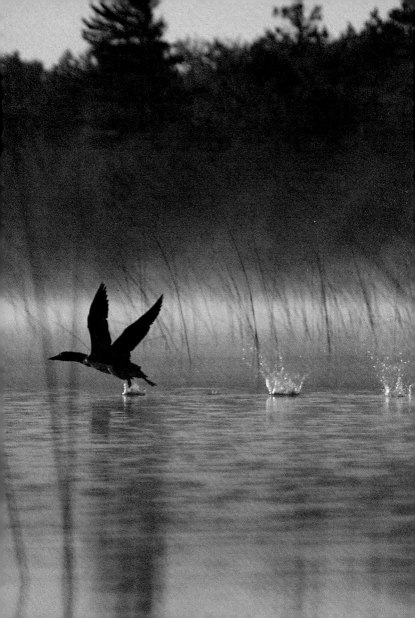

Then, without warning, the loon begins
to run across the calm lake surface.
After 100 yards it is airborne and it
circles the lake gaining altitude slowly.

The female on the nest wails and the flying loon gives a flight tremolo several times in reply. The loon flies over the forest surrounding the lake to a nearby large lake almost two miles away. As the lake comes into view, he gives the flight tremolo again.

On the lake below him there are many loons. One protests his arrival by giving the yodel call while a group of four loons becomes alert and watches him land.

The loon swims to the group of four and they begin some ritualistic behavior reminiscent of a dance.

Slowly and deliberately, they swim in a circle and then a figure eight, heads held high. Then, they dive in synchrony and resurface one at a time. After several minutes of this, the loon breaks away from the group and swims nearly 150 yards underwater to a shallow, weedy cove.

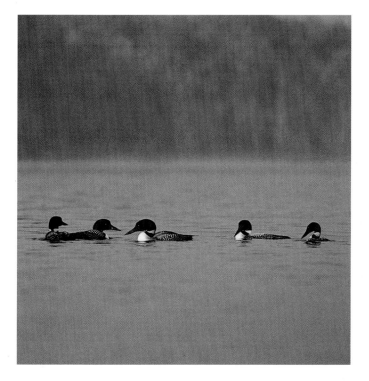

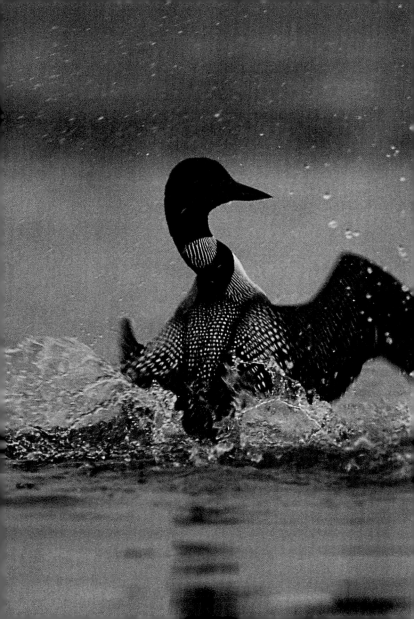

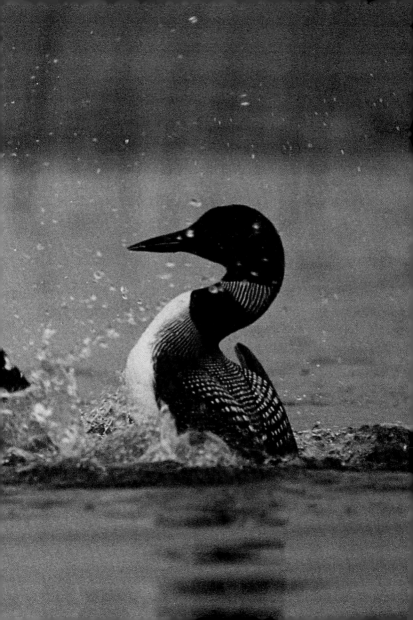

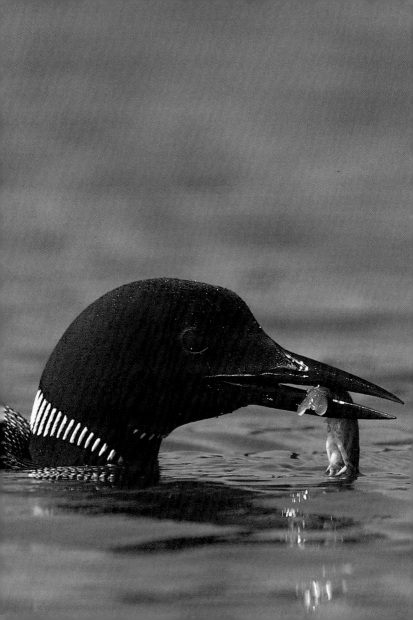

There he begins to swim slowly along the outer edge of the emergent vegetation, head held underwater, eyes fixed on the bottom.

A slow-moving crayfish becomes his first meal of the day.

He brings it to the surface and manipulates it in his bill before swallowing it whole. He catches several small fish in the next half hour and eats them underwater.

A distant wail turns his attention from feeding and he wails in response. Another wail is heard and he gives a wail back again.

Laboring a bit with a full crop, the loon runs across the water and flies off the lake.

Within three minutes, he lands on his home lake.

His mate on the nest wails again and he replies. He swims toward the nest. When he is within thirty feet, the female clambers off the nest and heads for the open lake. The male climbs awkwardly onto the nest and turns the eggs several times with his bill before settling down on them.

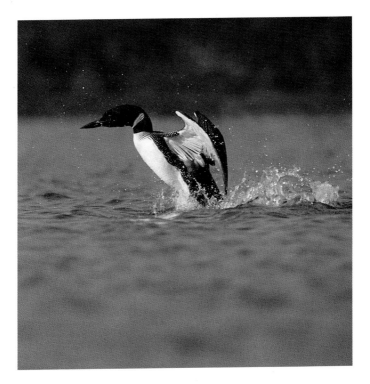

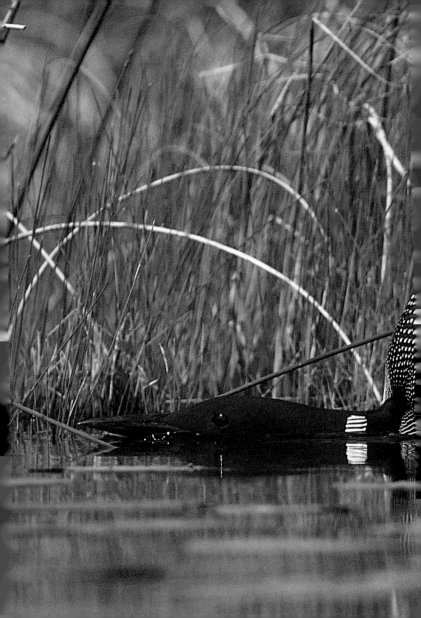

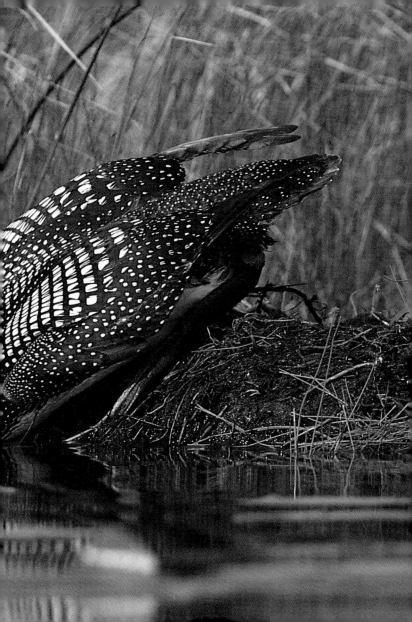

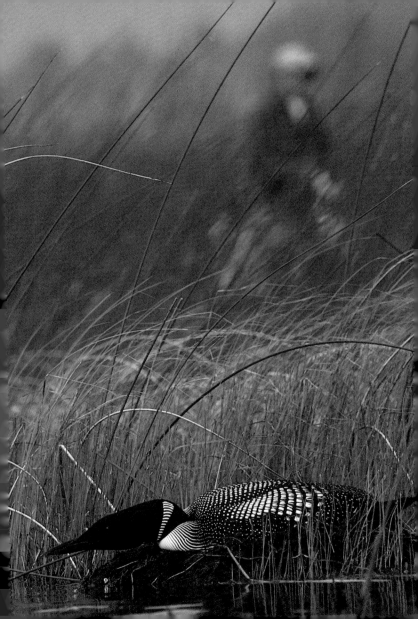

From the nest, he watches his mate feed and preen. He also watches the first activity of the humans in the camps on the opposite side of the lake. A slamming screen door and the sight of a dog running down the shore-line cause him to lie flat on the nest, his head held over the edge and his bill almost touch-ing the water. Some fishermen climb into a boat and start to motor along the shoreline.

As they round the corner of the lake and head into the cove, he stays in the "hangover" posture.

The boat passes the nest about 100 yards from shore, but the loon does not leave the nest.

As the human activity increases and the sounds of human voices and outboard motors become a droning hum, the loon closes one eye and then the other.

An excited tremolo
call from his mate
startles him awake.

Some children in a canoe have entered their cove and are heading right for the nest. His mate attempts to distract the canoeists by diving from one side of the canoe to the other. The children are unaware of the loon nest nearby and try to catch the female loon.

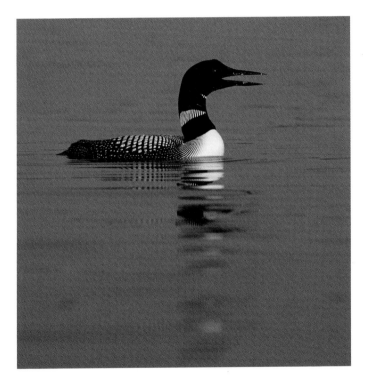

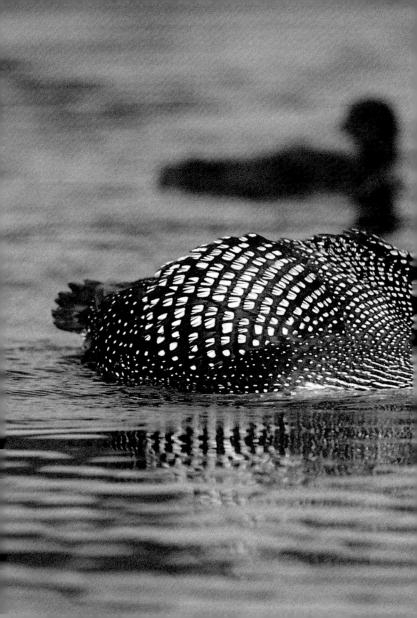

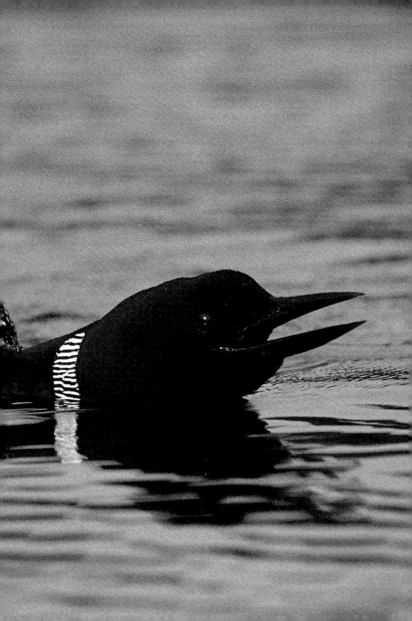

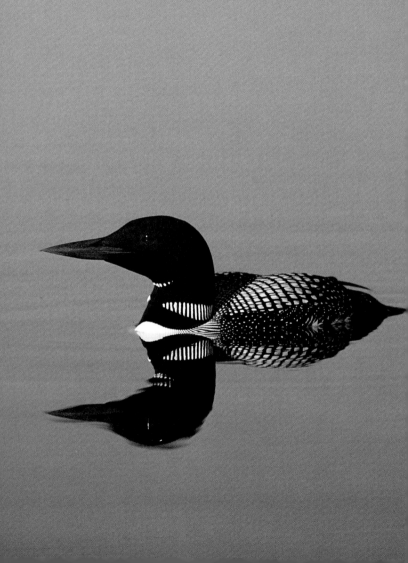

They paddle furiously, shouting and laughing, but the loon escapes easily by diving underwater. The children respond as if it's a game of hide and seek trying to guess where the loon will come up next. Purposely, she leads them to the open water part of the lake away from the nest. Then, she dives and swims all the way back to the nest underwater, leaving the children wondering where she could be.

Hooting softly, the loons trade places.

For an hour, the male sits motionless in the shadowed shallow water near the nest, watching the lake, preening occasionally.

Later, the loon swims out onto the lake toward the loon territory on the other side of a peninsula. He swims much of the way underwater surfacing only for a breath of air.

He stops near an area that serves as the boundary between the two territories where he sees another adult loon nearby feeding in the shallows.

He swims toward the loon. They interact nonaggressively for several minutes before a third loon approaches from behind an island.

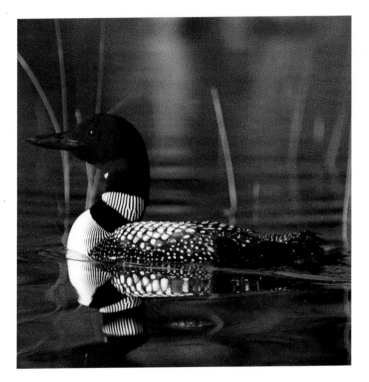

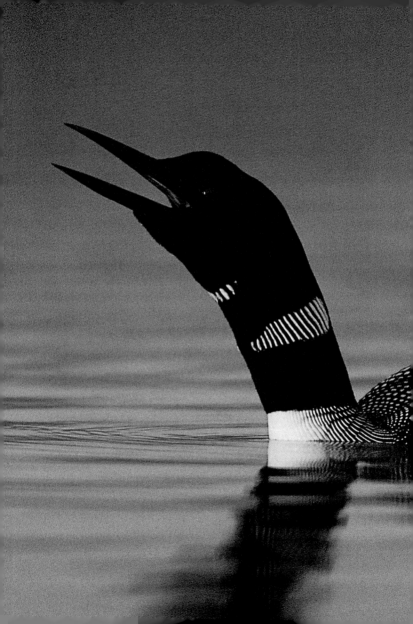

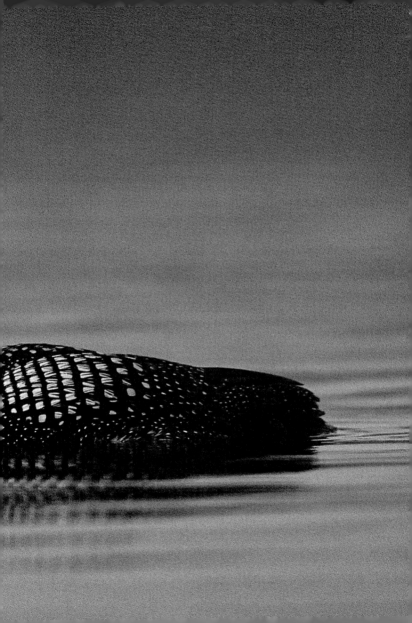

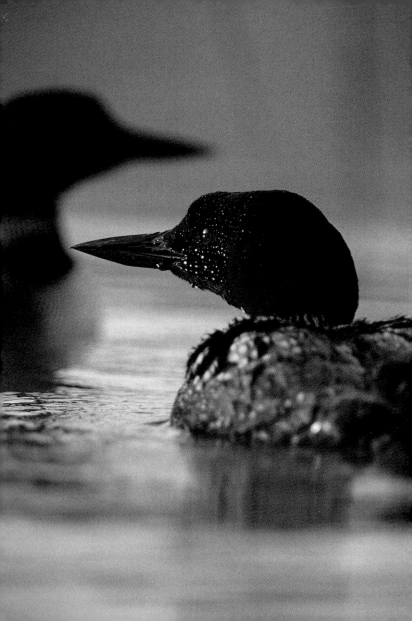

All three swim in a circle and dive several times before one of the loons lays his head low over the water and gives a yodel while the other bird watches from nearby.

Feeling a bit uncomfortable away from his own territory, the loon swims away and heads back toward the nest.

As he leaves, the other loon yodels two more times.

A large boat speeding across the water causes him to dive although it doesn't get closer than fifty yards. He swims to a shallow area in the cove and feeds and preens for nearly an hour.

He then swims back to the nest
where he finds his mate snapping at mosquitoes
and black flies buzzing around her head.

Upon seeing her mate nearby, she slips into the water for a cooling dip and relief from the flies. The loons leave the eggs uncovered for a half hour as they lazily feed, preen, and loaf. They perform some subtle, pair-bonding rituals that consist of synchronized head movements and shallow dives before the female returns to the nest.

For the rest of the afternoon, the male loon swims in his territory, occasionally preening and peering below the surface.

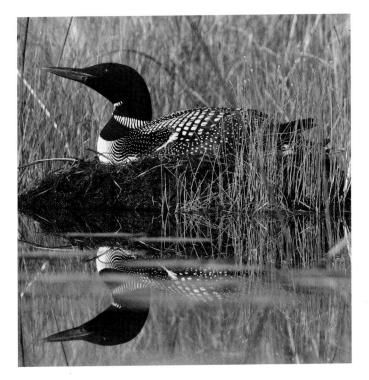

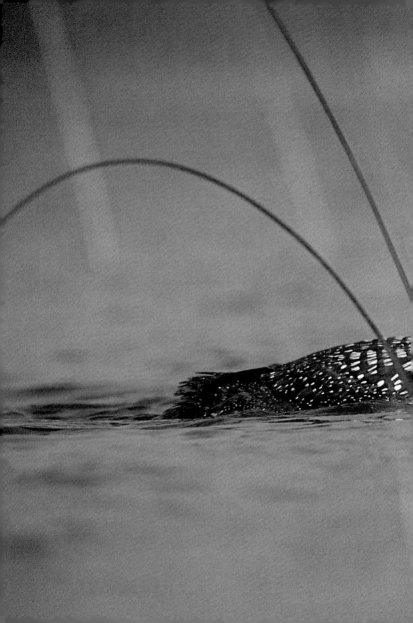

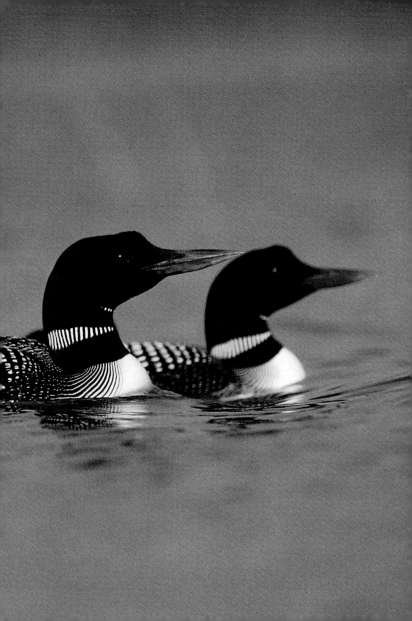

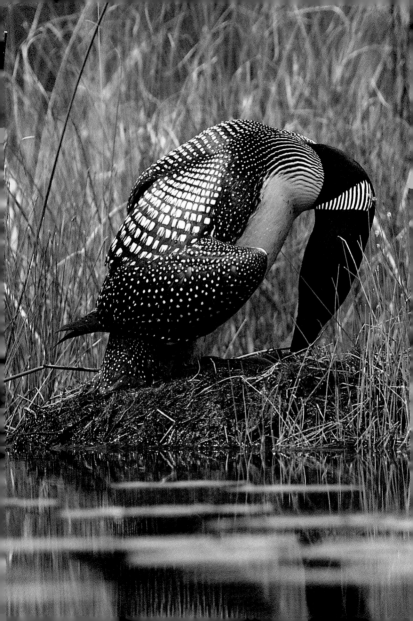

Several times, he stops and lifts one leg out of the water, shakes it, and tucks it up under one wing. Leaving one foot in the water as a rudder, he drifts with the wind, sometimes closing one or both eyes.

With the sun now low over the treetops, the loon swims back to the nest and relieves his mate of incubation duties.

He turns the eggs again and picks at some vegetation with his bill, adding a few sticks and blades of grass to the shallow nest bowl.

His mate is off feeding as he watches the activity on the lake.

A stick breaking behind him in the forest causes him to become motionless and to lie low on the nest. More sounds and the approach of an animal make him slip off the nest silently and he swims several yards from the shore. A white-tailed deer walks out of the forest and comes to the water's edge to drink. It walks along the shore in the shallow water directly in front of the loon's nest. After it leaves, the loon returns to the nest.

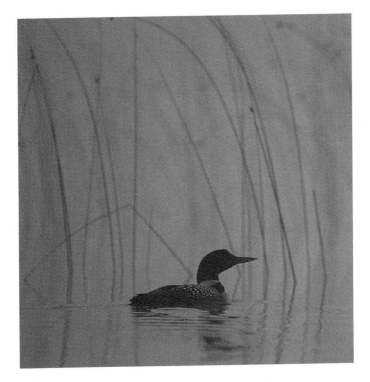

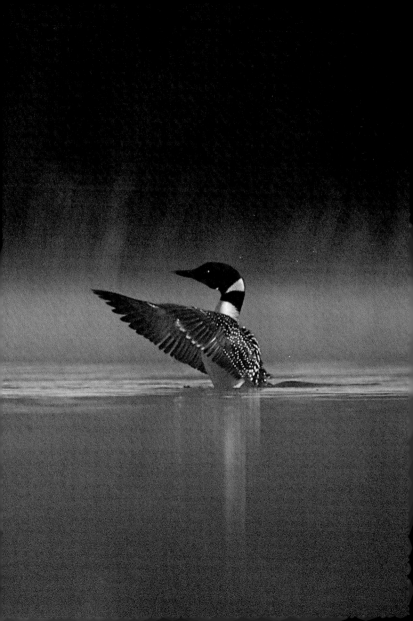

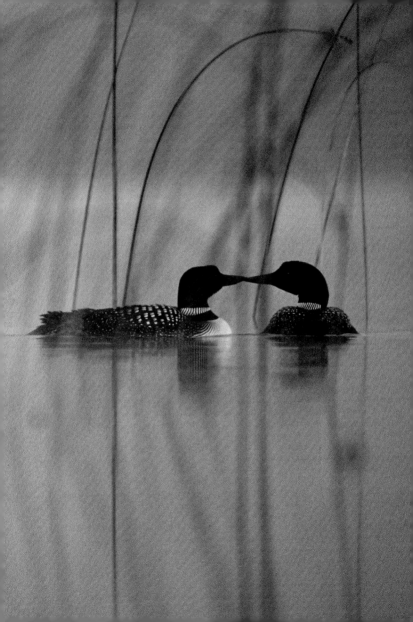

Just before nightfall, the loon on the nest hears the flight tremolo of an approaching loon and sees it land on the lake near his mate.

The female and the visitor swim together for fifteen minutes before the visitor swims off toward the other loon territory.

The female returns to the nest and they switch places again. This time the male swims out to the middle of the territory where he preens and swims around with no apparent destination.

Several hours after the sky has become dark, some people go out in a boat with bright lights and a noisy motor. The loon gives a tremolo call four times and the loons in the other territory call also. From nearby lakes more tremolos are heard. Then the lake becomes quiet.

Sitting out on the lake away from the nest, the male loon gives a wail call several times. His wails echo off the water and trees and he calls again.

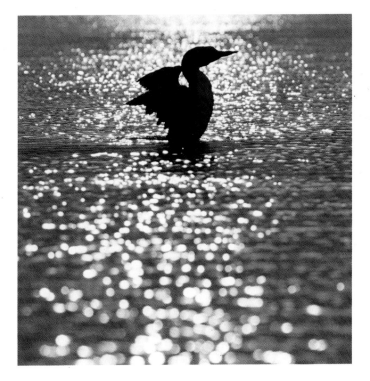

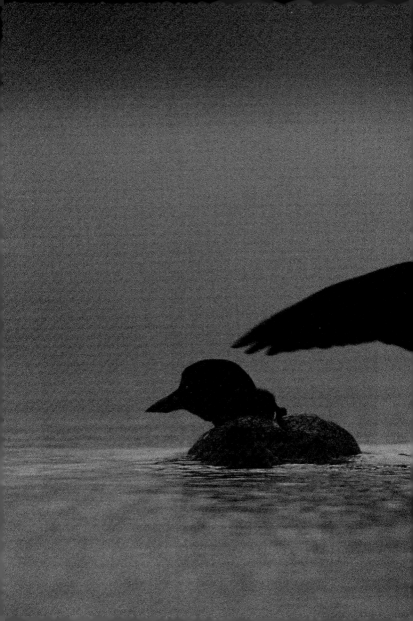

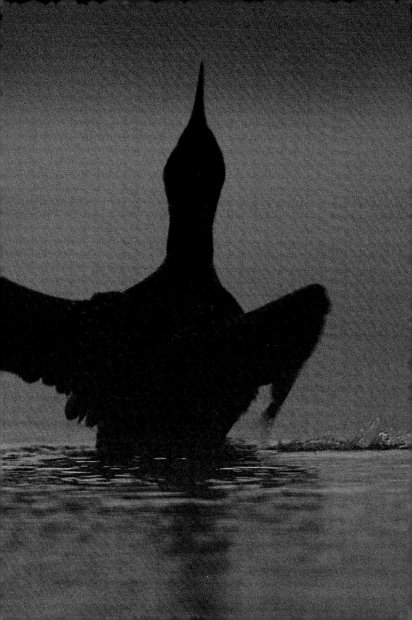

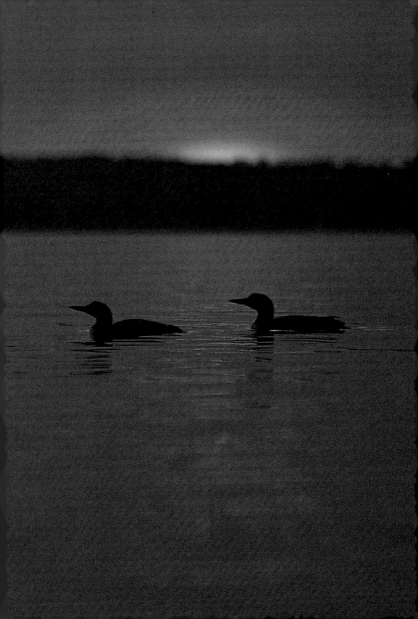

He hears wails, tremolos, and yodels from the other loons on the lake and from loons on other lakes.

*He continues to call,
chorusing with the other loons.*

At one point, he stretches his neck over the water and gives the yodel call several times.

Later, he swims back into the cove and gives a couple of hoot calls. His mate hoots back softly and they change places once again. He sits quietly on the nest for several hours listening intently to the night sounds. Nearby, his mate sleeps on the water.

Then, he sees the first light of dawn.

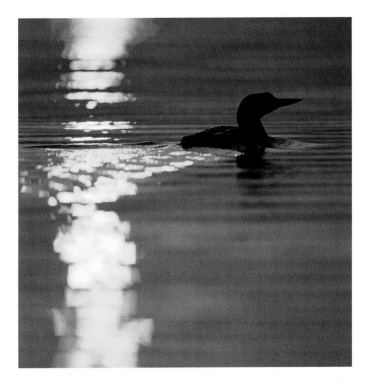

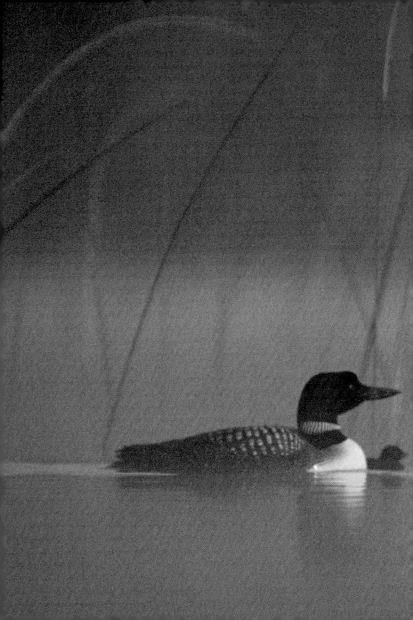

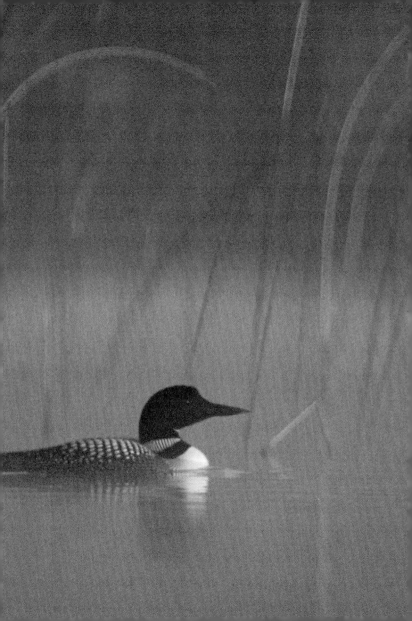

Book design by Russell S. Kuepper
Feather illustrations by Kenneth Hey

The text and photographs have been adapted for this edition from *Loon Magic* by Tom Klein with photography by Carl R. Sams II and Jean Stoick.

NorthWord Press
5900 Green Oak Drive
Minnetonka, MN 55343
1-800-328-3895

Library of Congress Cataloging-in-Publication Data
Klein, Tom
 Voice of the waters / Tom Klein ; photography by Carl R. Sams II
and Jean Stoick.
 p. cm.
 ISBN 1-55971-710-6 (hc.)
 1. Loons. 2. Loons Pictorial works. I. Sams, Carl R.
II. Stoick, Jean. III. Title.
QL696.G33K56 1999
598.4'42--dc21 99-30925

Printed in Singapore